LEVEL II · JEDI KNIGHTS

Draw seasonal illustrations, silhouettes, and emblems.

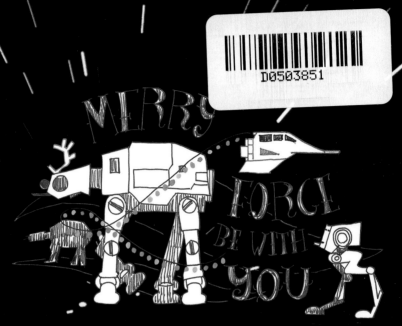

MERRY FORCE BE WITH YOU

LEVEL III · JEDI MASTERS

Draw *Star Wars* patterns.

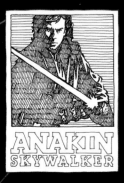

ANAKIN SKYWALKER

HAN SOLO

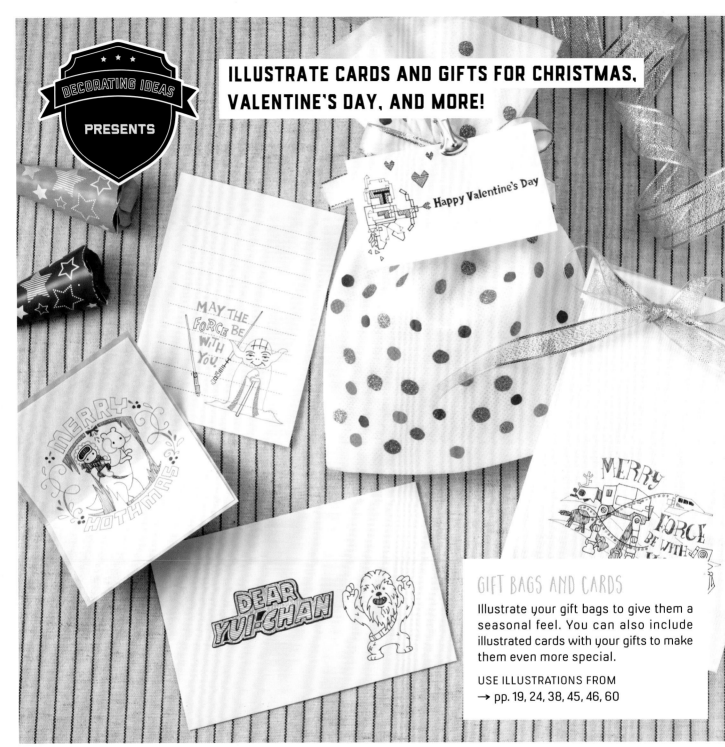

ILLUSTRATE CARDS AND GIFTS FOR CHRISTMAS, VALENTINE'S DAY, AND MORE!

Happy Valentine's Day

MAY THE FORCE BE WITH YOU,

MERRY HOTHMAS

DEAR YUI-CHAN

MERRY FORCE BE WITH

GIFT BAGS AND CARDS

Illustrate your gift bags to give them a seasonal feel. You can also include illustrated cards with your gifts to make them even more special.

USE ILLUSTRATIONS FROM
→ pp. 19, 24, 38, 45, 46, 60

DRAW *STAR WARS* ILLUSTRATIONS ON HOUSEHOLD ITEMS AND MAKE EVERY DAY MORE FUN!

SHOES

Transform plain shoes by combining logos and patterns with *Star Wars* character illustrations.

USE ILLUSTRATIONS FROM
→ pp. 32, 37, 48

TOTE BAGS

Larger illustrations are more eye-catching! Design your own original bags and become a trendsetter.

USE ILLUSTRATIONS FROM
→ p. 39

PERSONALIZE YOUR TUMBLERS AND JARS AND MAKE THEM UNIQUE. ADD A TOUCH OF COLOR FOR A FUN SNACK-TIME EXPERIENCE!

TUMBLER AND JARS

Look at the *Star Wars*-inspired lettering on these containers and jars. On the tumbler on the left, the labels have been stuck on its surface at random. The illustrations on the two jars will definitely stand out on the shelf!

USE ILLUSTRATIONS FROM
→ pp. 60, 61

PAPER CUPS, COASTERS, AND PAPER NAPKINS

Illustrate your paper cups, coasters, and napkins with popular *Star Wars* characters and enjoy snack time! Refer to the silhouettes on page 48 to draw each character's name.

USE ILLUSTRATIONS FROM → pp. 11, 12, 13, 14

LUKE

LEIA

DARTH VADER

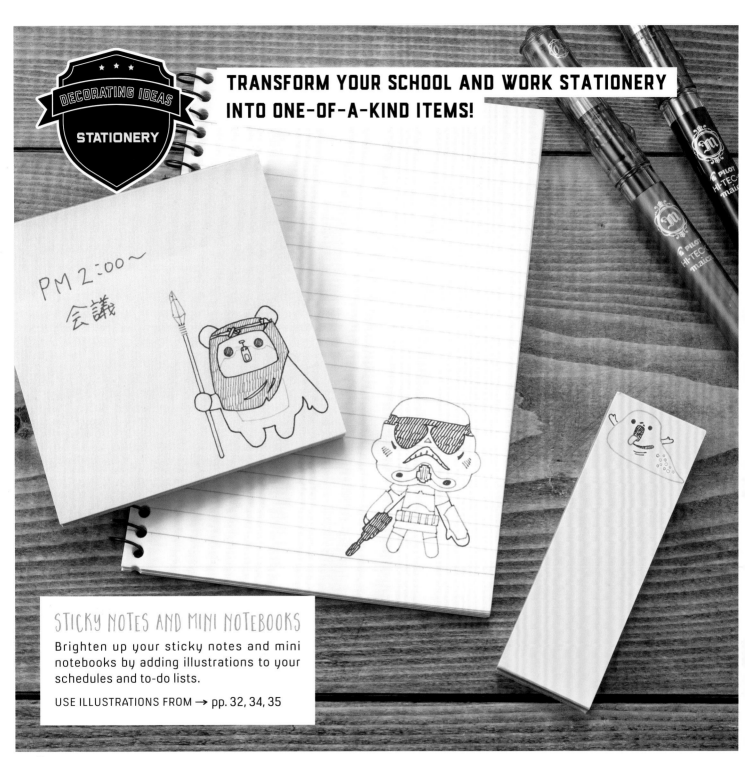

TRANSFORM YOUR SCHOOL AND WORK STATIONERY INTO ONE-OF-A-KIND ITEMS!

DECORATING IDEAS
STATIONERY

PM 2:00〜
会議

STICKY NOTES AND MINI NOTEBOOKS

Brighten up your sticky notes and mini notebooks by adding illustrations to your schedules and to-do lists.

USE ILLUSTRATIONS FROM → pp. 32, 34, 35

NOTEBOOKS AND CARD CASES

Draw realistic, detailed illustrations on your notebook covers and card cases to create stylish products. Surprise everyone with your great illustration skills!

USE ILLUSTRATIONS FROM → pp. 59, 63

TYPES OF BALLPOINT PENS

Ballpoint pens come in a variety of ink colors and line weights. Once you're familiar with the different characteristics of each pen, start drawing your favorite illustrations.

TYPES OF INKS

WATERCOLOR INKS

Watercolor inks are created from a mixture of water and pigments or dyes. They provide a smooth writing flow and come in vibrant colors. But be careful that the inks don't get wet, as they will run or bleed through.

GEL INKS

These are watercolor inks that contain gelling agents. The drawing flow is smooth, and the inks don't dissolve easily.

OIL-BASED INKS

Oil-based inks are made of oils mixed with pigments. The drawing flow is a bit thick. These inks don't run or fade easily, so use them when you want to preserve illustrations for a long time.

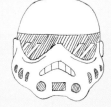

OTHER TYPES OF PENS WE RECOMMEND

ERASABLE GEL INK PENS

PASTEL COLOR PENS

FABRIC MARKERS

The ink colors disappear when erased. Since you can redraw easily, don't worry about making mistakes in your illustrations.

Use pastel color pens in softer tones to draw cute illustrations. Pastel colors stand out in photos.

Fabric markers are watercolor inks that are brilliant, don't run, and hardly fade in the wash. Recommended for illustrating cloth or plain shoes, as shown in this book.

VARIOUS LINE WEIGHTS

Each pen has a different line weight. When the line weight changes, the impression of the illustration also changes. To give your illustrations a unique flair, use a pen with a fine point; to make them cute, use a thick pen.

0.3 mm

0.4 mm

0.5 mm

0.7 mm

HOW TO USE THIS BOOK

Introducing the pens and paper used for the illustrations in this book.

ABOUT BALLPOINT PENS

Most of the illustrations in this book are drawn using 0.4 mm gel ink pens. The line style is smooth and the ink doesn't dissolve easily.

ABOUT PAPERS

The type of paper used in this book is copy paper. The texture of the paper is just right—not too smooth or too rough, so the inks won't smudge easily, and you can draw on it easily, too. Since it is difficult to draw on coated paper and rough paper, use these after you have learned how to draw the illustrations.

HOW TO DRAW ILLUSTRATIONS

Follow the arrows step-by-step and see your illustrations come to life right before your eyes! Start by following the instructions, but once you are familiar with them, feel free to draw in whatever order you like.

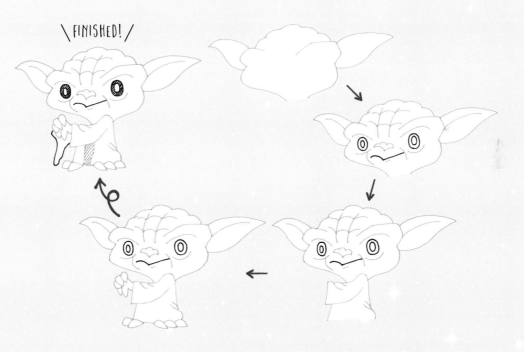

\ FINISHED! /

PADAWANS

Draw popular *Star Wars* characters in a variety of drawing styles.

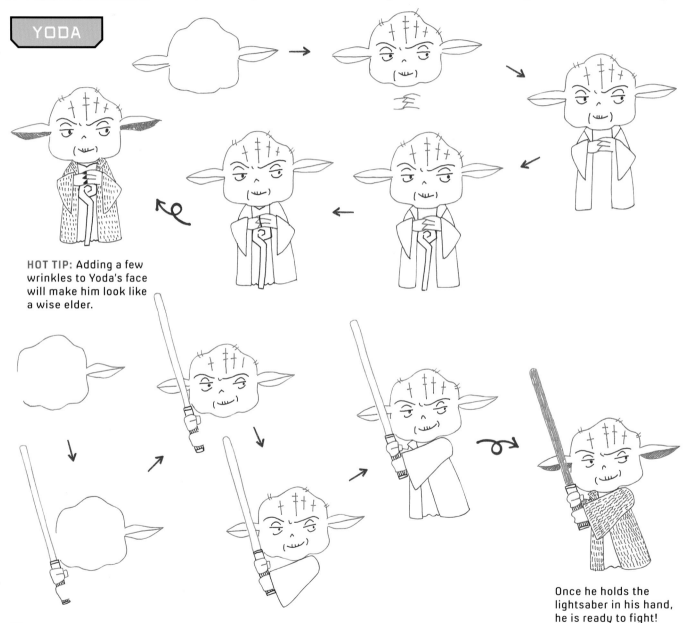

YODA

HOT TIP: Adding a few wrinkles to Yoda's face will make him look like a wise elder.

Once he holds the lightsaber in his hand, he is ready to fight!

DARTH VADER

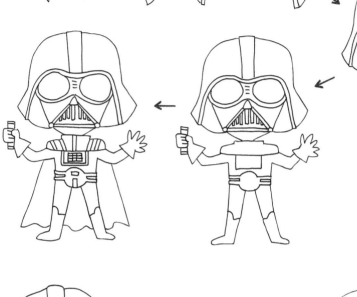

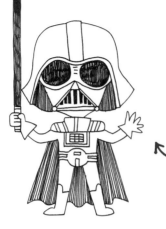

The Dark Lord of the Sith is standing with his hand outstretched.

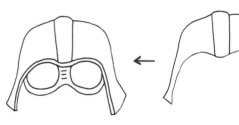

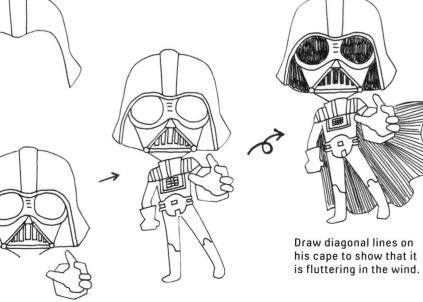

Draw diagonal lines on his cape to show that it is fluttering in the wind.

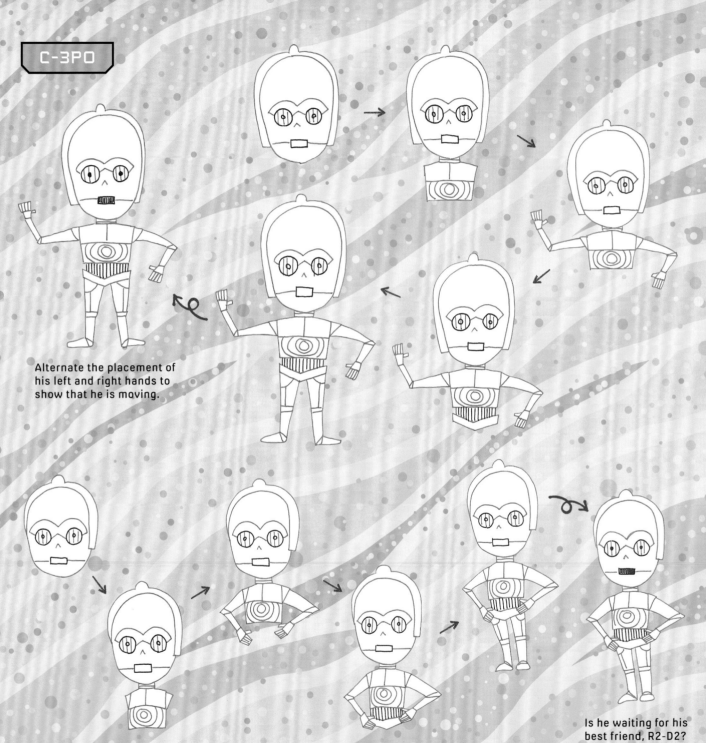

Alternate the placement of his left and right hands to show that he is moving.

Is he waiting for his best friend, R2-D2?

12

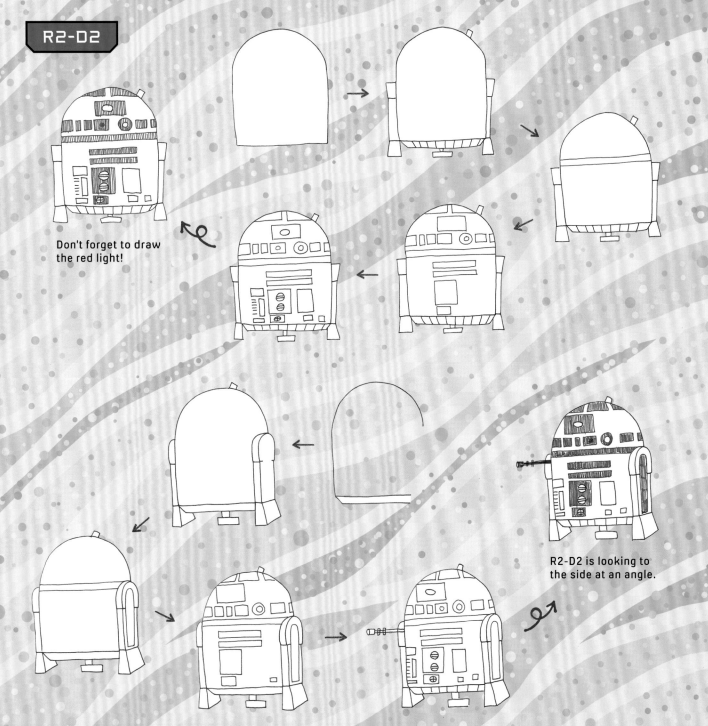

R2-D2

Don't forget to draw the red light!

R2-D2 is looking to the side at an angle.

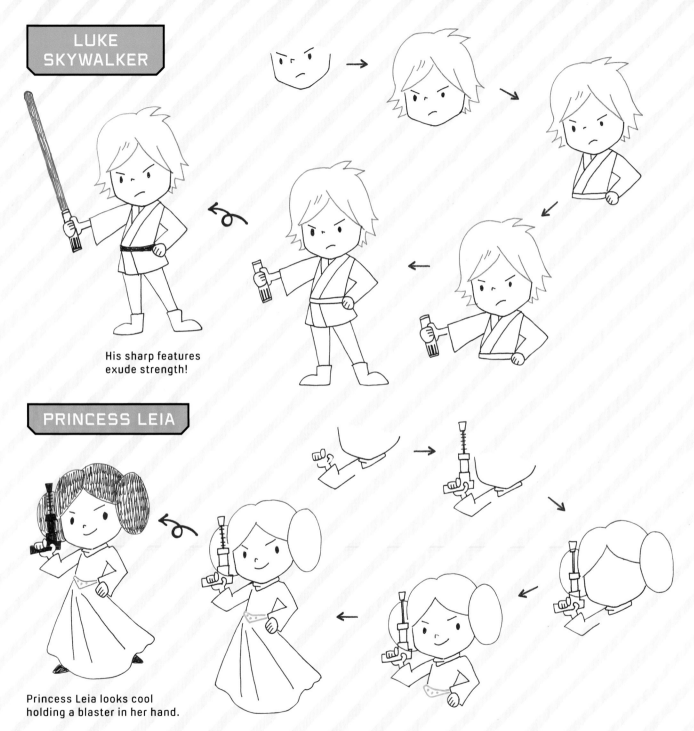

LUKE SKYWALKER

His sharp features
exude strength!

PRINCESS LEIA

Princess Leia looks cool
holding a blaster in her hand.

CHEWBACCA

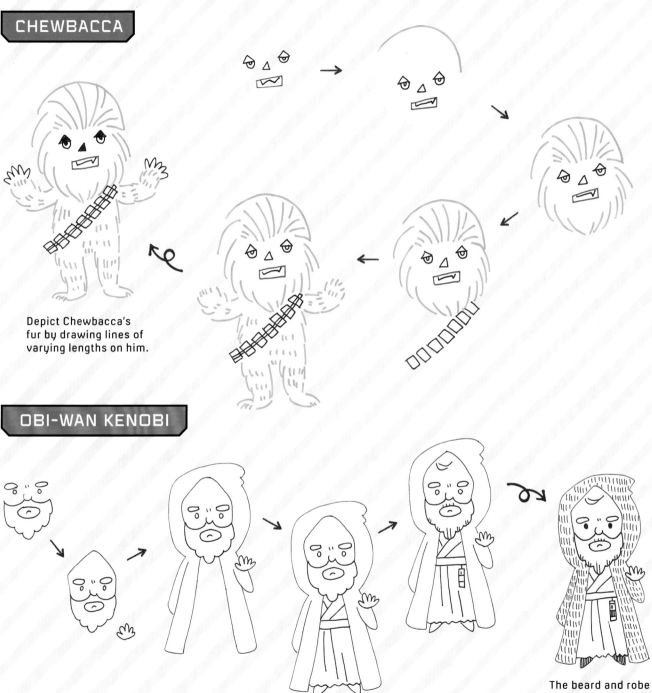

Depict Chewbacca's fur by drawing lines of varying lengths on him.

OBI-WAN KENOBI

The beard and robe are his trademarks.

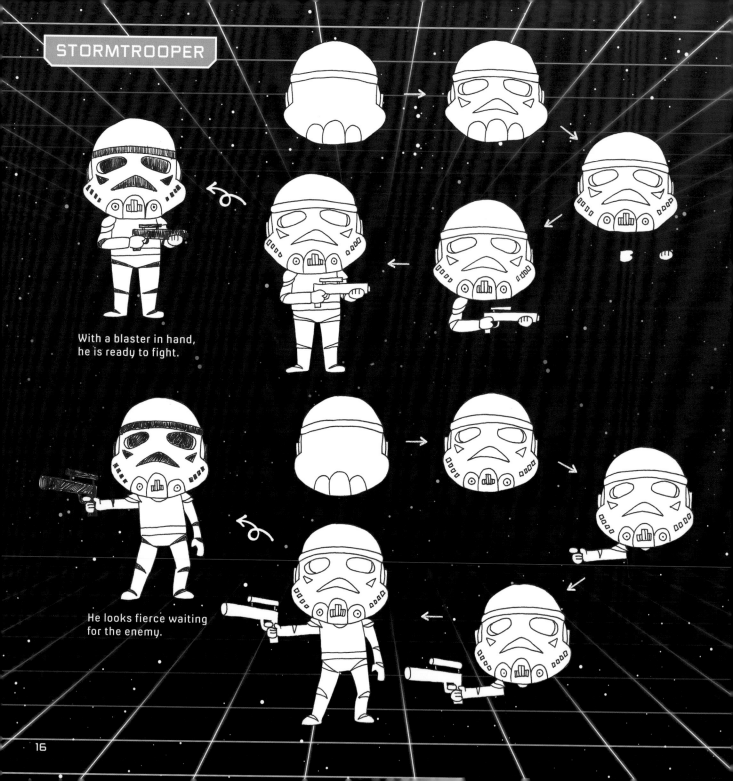

With a blaster in hand, he is ready to fight.

He looks fierce waiting for the enemy.

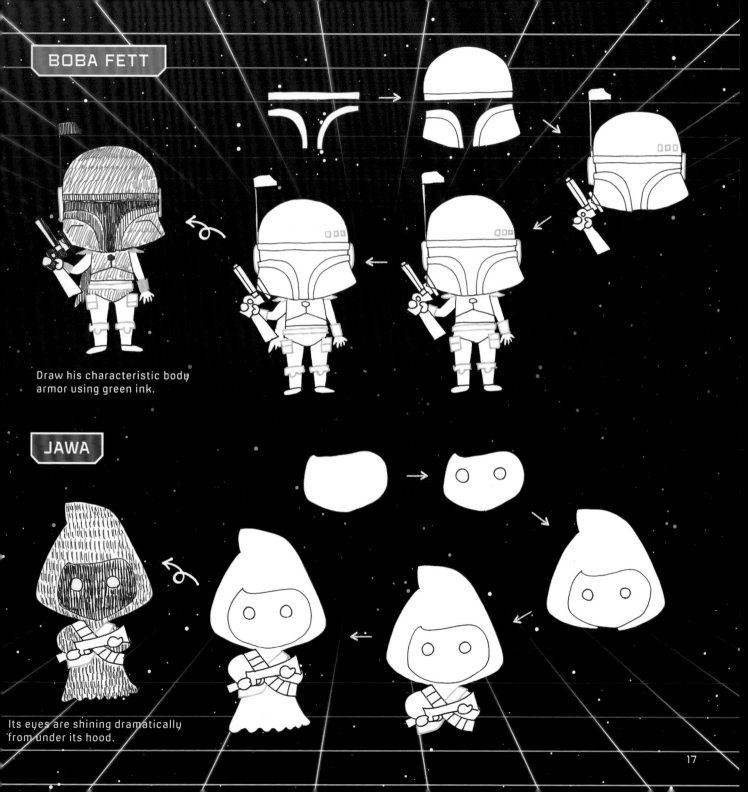

BOBA FETT

Draw his characteristic body armor using green ink.

JAWA

Its eyes are shining dramatically from under its hood.

SIMPLE STYLE

Draw characters with a comical and characteristic touch.

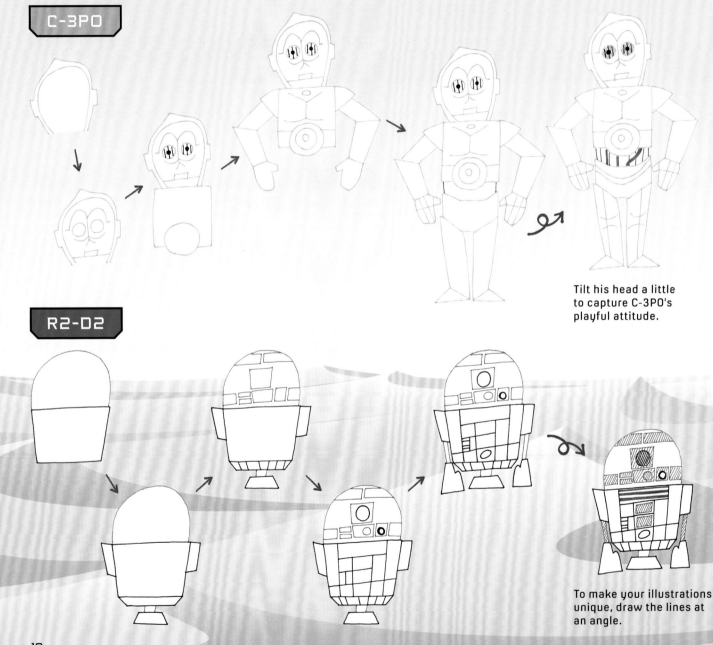

C-3PO

Tilt his head a little to capture C-3PO's playful attitude.

R2-D2

To make your illustrations unique, draw the lines at an angle.

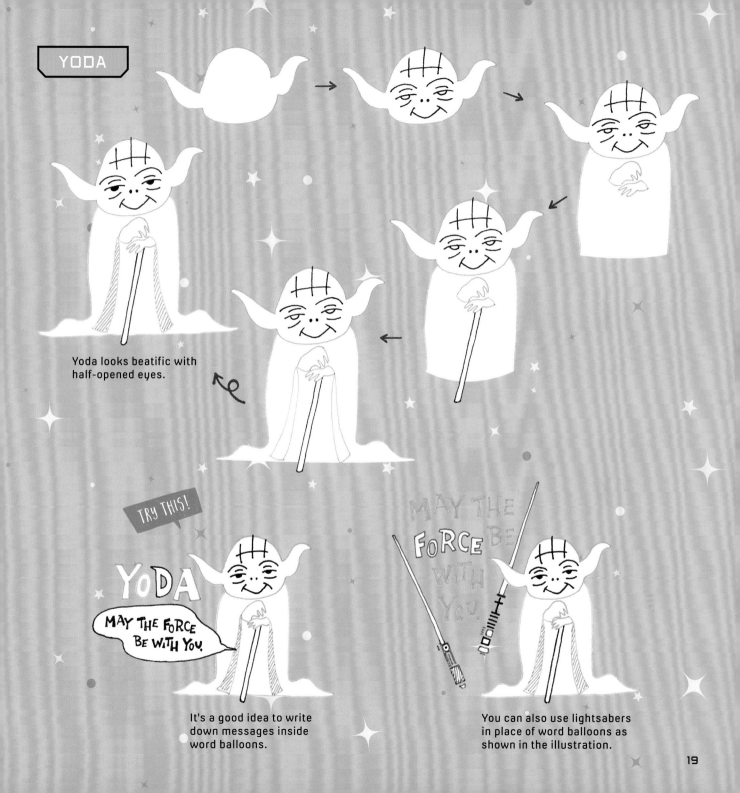

Yoda looks beatific with half-opened eyes.

TRY THIS!

YODA

MAY THE FORCE BE WITH YOU.

It's a good idea to write down messages inside word balloons.

MAY THE FORCE BE WITH YOU

You can also use lightsabers in place of word balloons as shown in the illustration.

Darth Vader is standing
straight and rigid.

R2-D2

BEEP

R2-D2

Decorate the character's
name with illustrations.

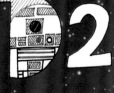

R2, WHERE
HAVE YOU BEEN?

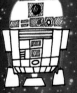

R2-D2

C-3PO

R2-D2 and C-3PO are
such good friends.

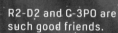

This stormtrooper is spacing out.

TRY THIS!

He looks adorable and laid-back with his neck tilted.

MOVE ALONG...

STORMTROOPER

Draw stormtroopers side-by-side and group them into fun formations.

21

COMIC STYLE

The key to drawing two-head-tall characters is to draw them using simple poses.

DARTH VADER

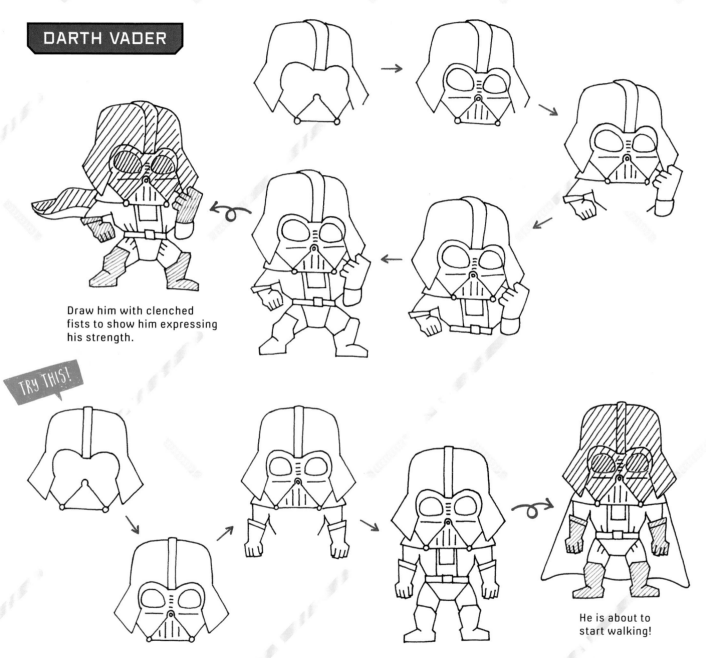

Draw him with clenched fists to show him expressing his strength.

TRY THIS!

He is about to start walking!

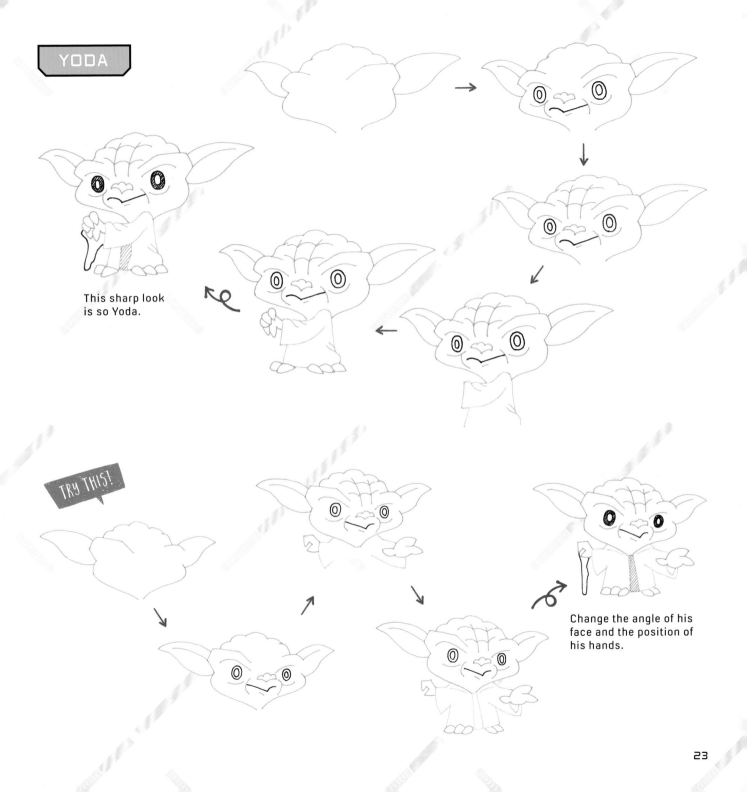

YODA

This sharp look is so Yoda.

TRY THIS!

Change the angle of his face and the position of his hands.

R2-D2

R2-D2 is leaning backward.

CHEWBACCA

Opening Chewbacca's mouth widely makes him look cheerful.

STORMTROOPER

This stormtrooper seems highly motivated.

BOBA FETT

His firm pose is so charming.

DOODLE STYLE

An easy way to replicate this illustration is by using the simple doodle style.

YODA

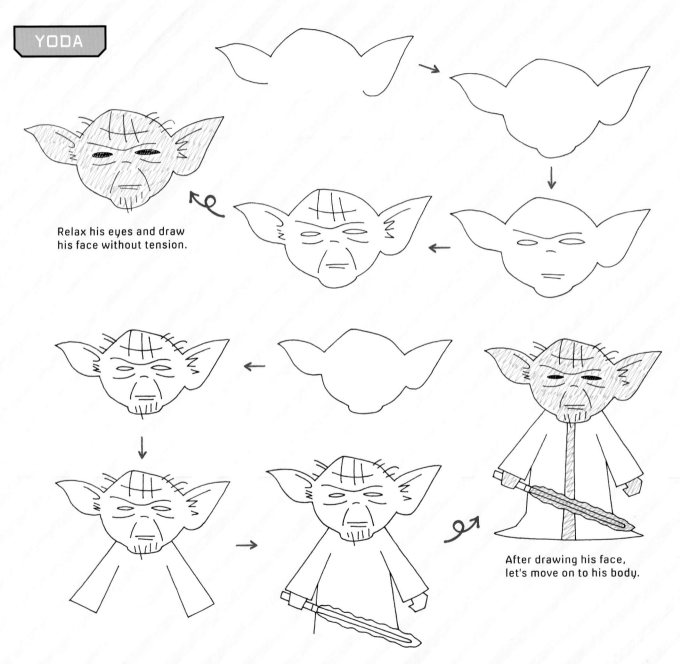

Relax his eyes and draw his face without tension.

After drawing his face, let's move on to his body.

Use diagonal lines in the illustration to make it original.

C-3PO

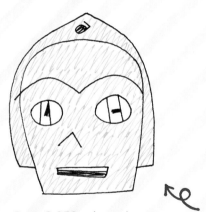

Draw C-3PO using only a few specific details of his face to give him a different facial expression from that of the original C-3PO.

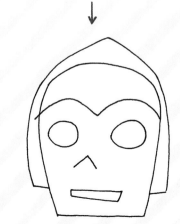

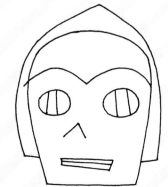

CUTE STYLE

Draw the characters' facial expressions and poses in a cute style.

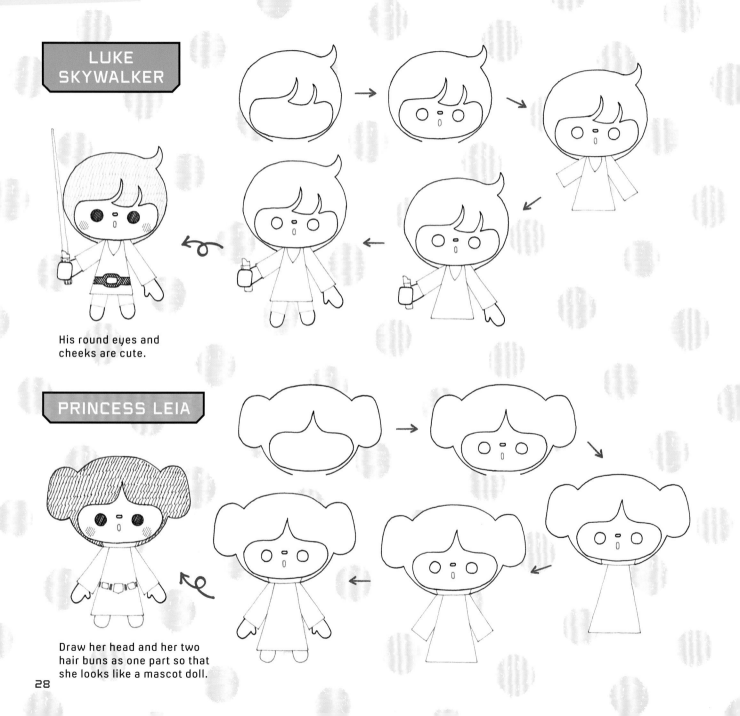

LUKE SKYWALKER

His round eyes and cheeks are cute.

PRINCESS LEIA

Draw her head and her two hair buns as one part so that she looks like a mascot doll.

28

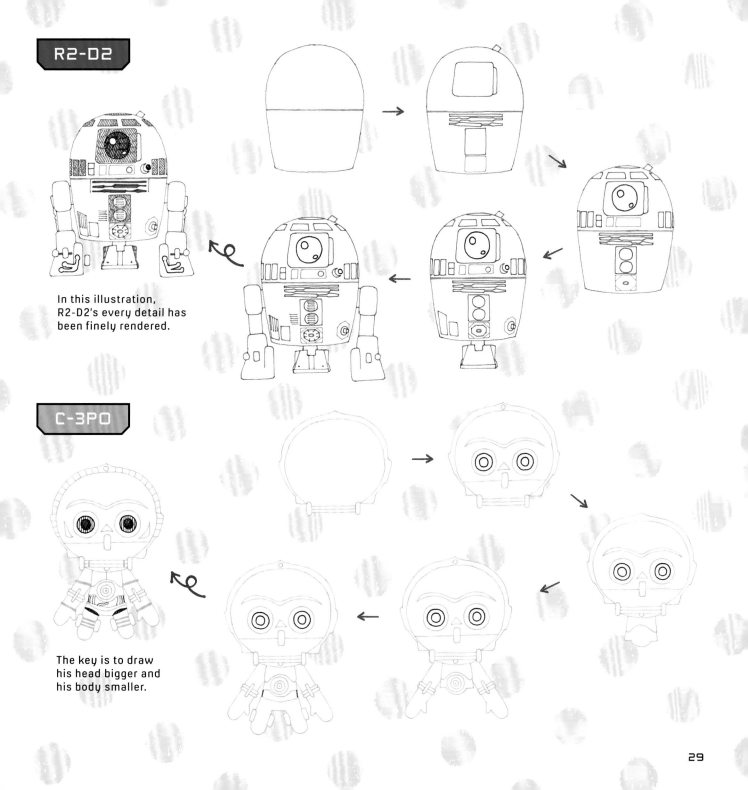

R2-D2

In this illustration, R2-D2's every detail has been finely rendered.

C-3PO

The key is to draw his head bigger and his body smaller.

HAN SOLO

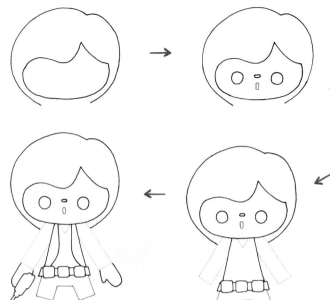

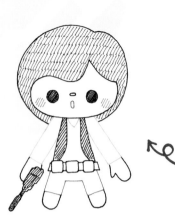

You can always recognize Han Solo from his vest and blaster.

CHEWBACCA

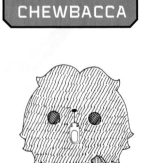

Don't forget to draw his weapon and give him fangs.

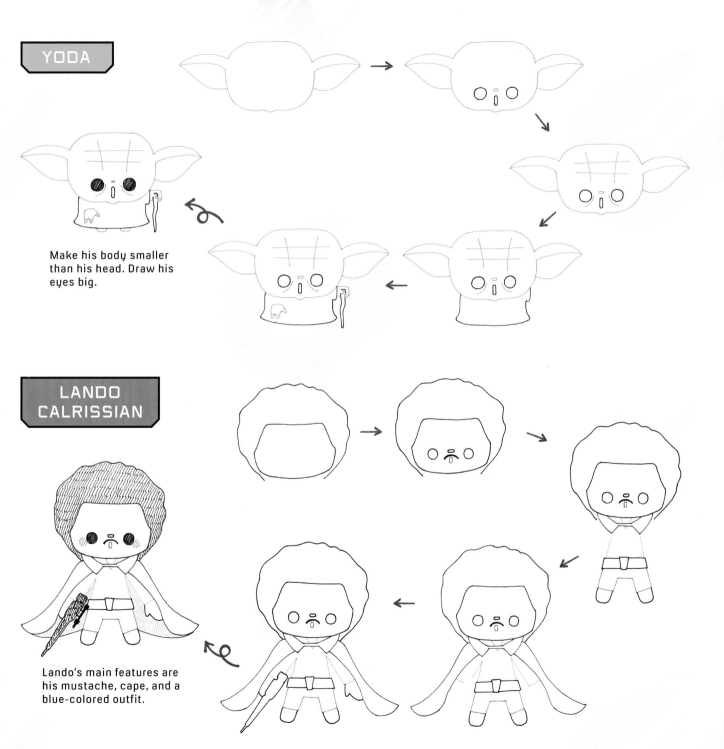

YODA

Make his body smaller than his head. Draw his eyes big.

LANDO CALRISSIAN

Lando's main features are his mustache, cape, and a blue-colored outfit.

DARTH VADER

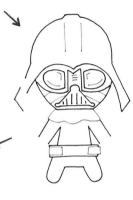

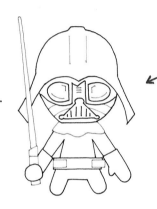

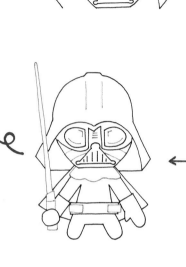

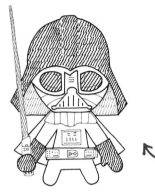

Draw Darth Vader's head and body in almost the same proportions.

STORMTROOPER

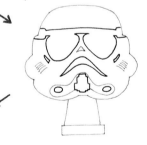

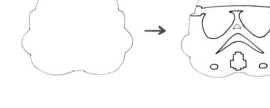

Similar to Darth Vader, make a 1:1 proportion between his head and his body.

STORMTROOPER AND DEWBACK

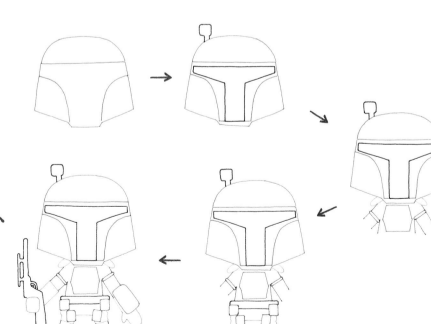

Since a dewback is huge, the stormtrooper sitting on it should be drawn small.

BOBA FETT

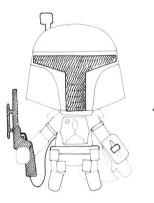

Draw him in the same proportions as Darth Vader.

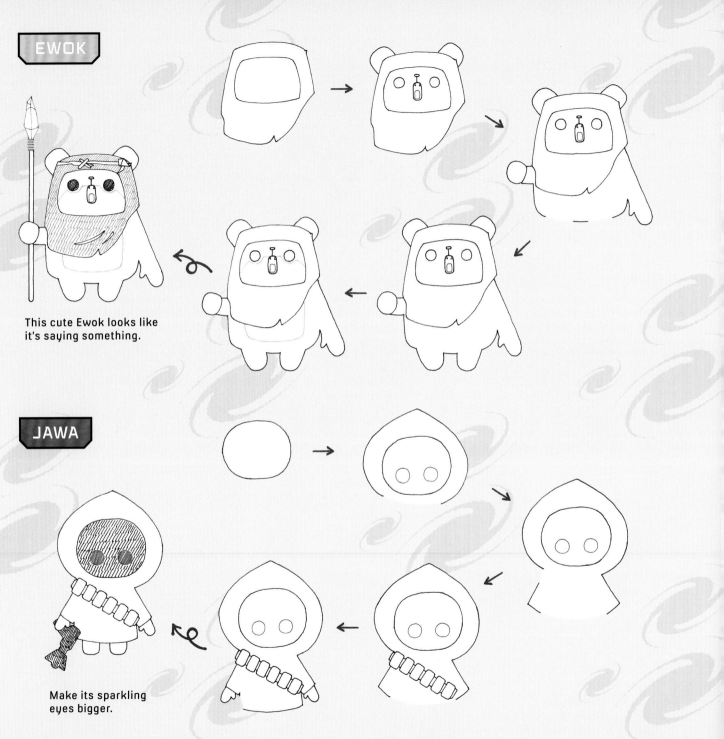

EWOK

This cute Ewok looks like it's saying something.

JAWA

Make its sparkling eyes bigger.

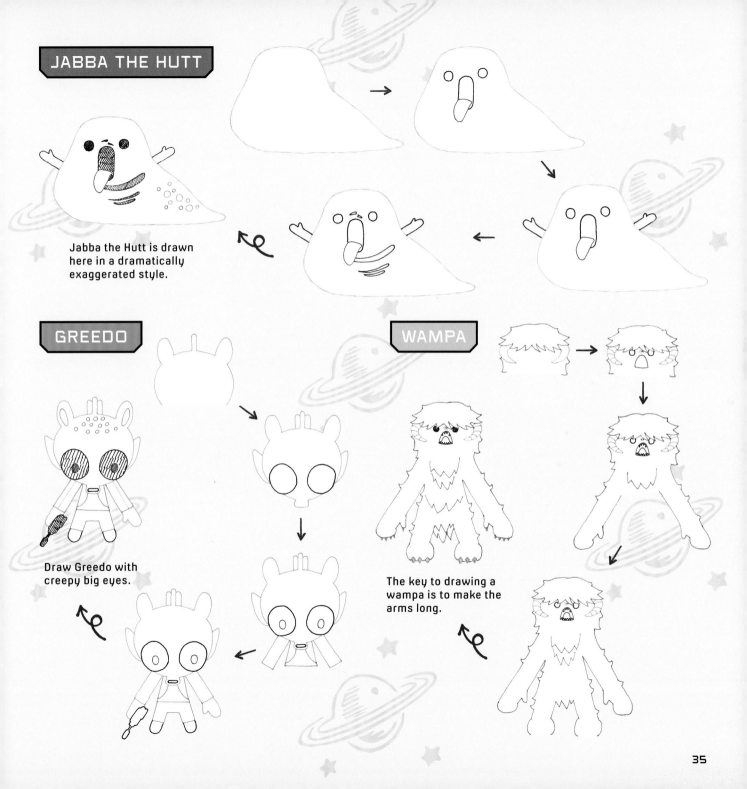

JABBA THE HUTT

Jabba the Hutt is drawn here in a dramatically exaggerated style.

GREEDO

Draw Greedo with creepy big eyes.

WAMPA

The key to drawing a wampa is to make the arms long.

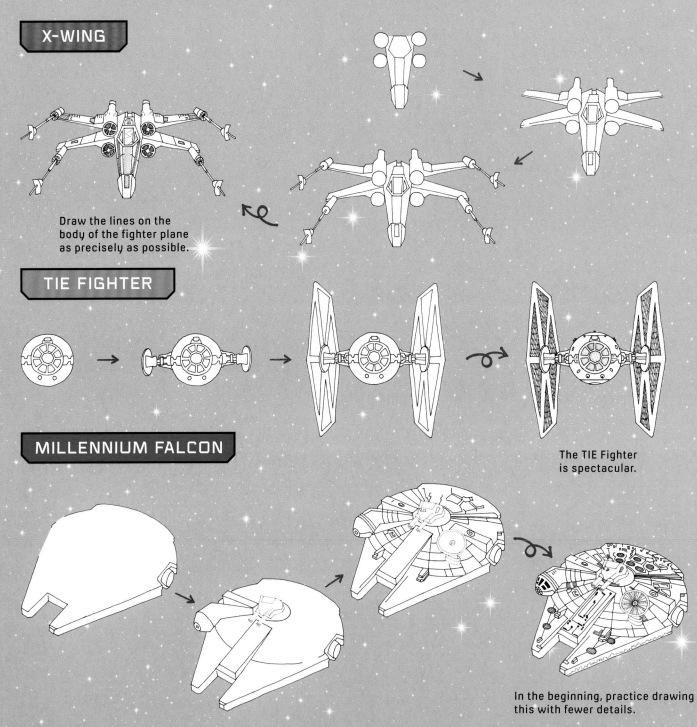

X-WING

Draw the lines on the body of the fighter plane as precisely as possible.

TIE FIGHTER

The TIE Fighter is spectacular.

MILLENNIUM FALCON

In the beginning, practice drawing this with fewer details.

DRAW DIFFERENT CHARACTERS TOGETHER IN VARIOUS COMBINATIONS.

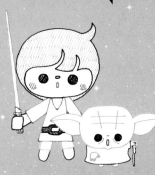

Draw Luke from page 28 and Yoda from page 31 together.

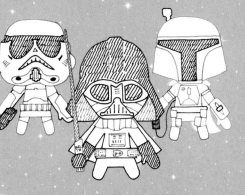

Draw Darth Vader and the stormtrooper from page 32 and Boba Fett from page 33 together.

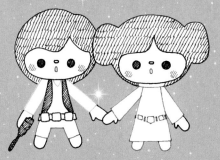

Draw Princess Leia from page 28 and Han Solo from page 30 together.

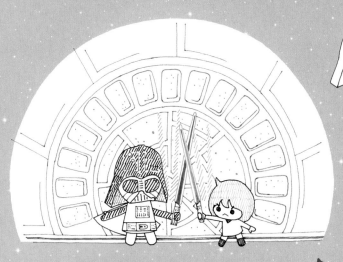

This is an illustration of Darth Vader and Luke Skywalker having a fight. Draw the background for this fight scene.

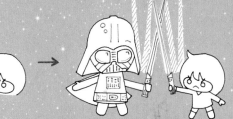

VALENTINE'S DAY

These cute illustrations are full of pink and red hearts.

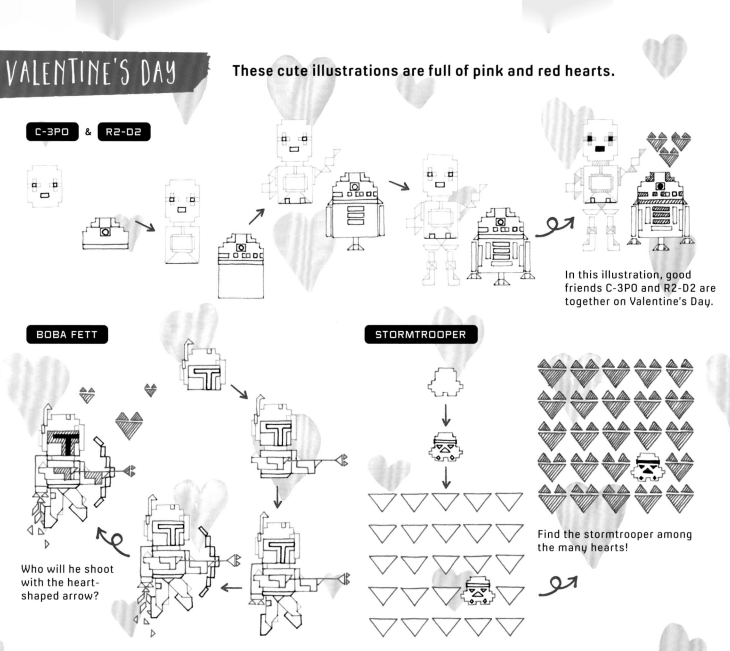

C-3PO & R2-D2

In this illustration, good friends C-3PO and R2-D2 are together on Valentine's Day.

BOBA FETT

Who will he shoot with the heart-shaped arrow?

STORMTROOPER

Find the stormtrooper among the many hearts!

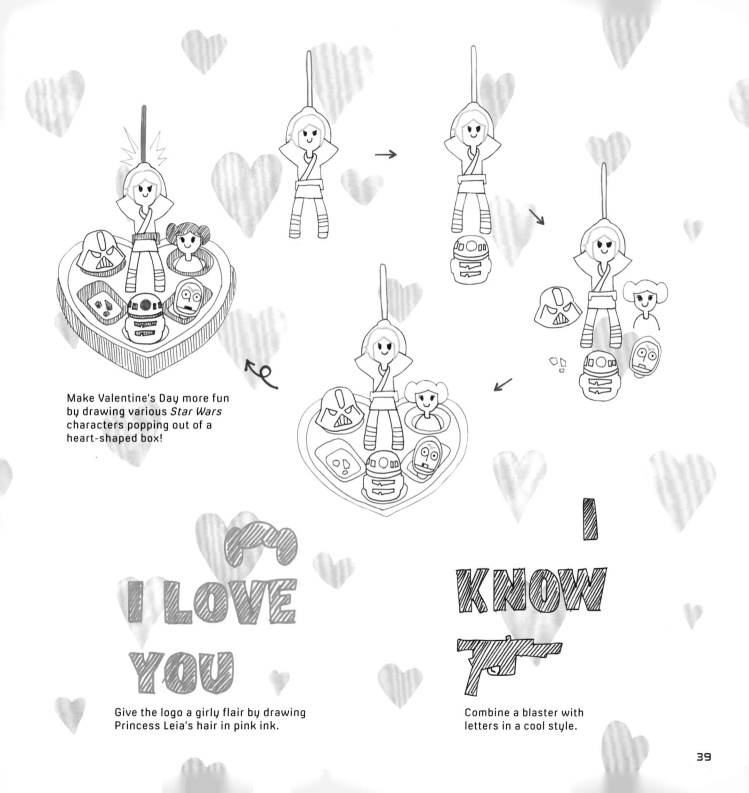

Make Valentine's Day more fun by drawing various *Star Wars* characters popping out of a heart-shaped box!

I LOVE YOU

Give the logo a girly flair by drawing Princess Leia's hair in pink ink.

I KNOW

Combine a blaster with letters in a cool style.

Draw illustrations of *Star Wars* characters on Easter eggs.

DARTH VADER

STORMTROOPER

BOBA FETT

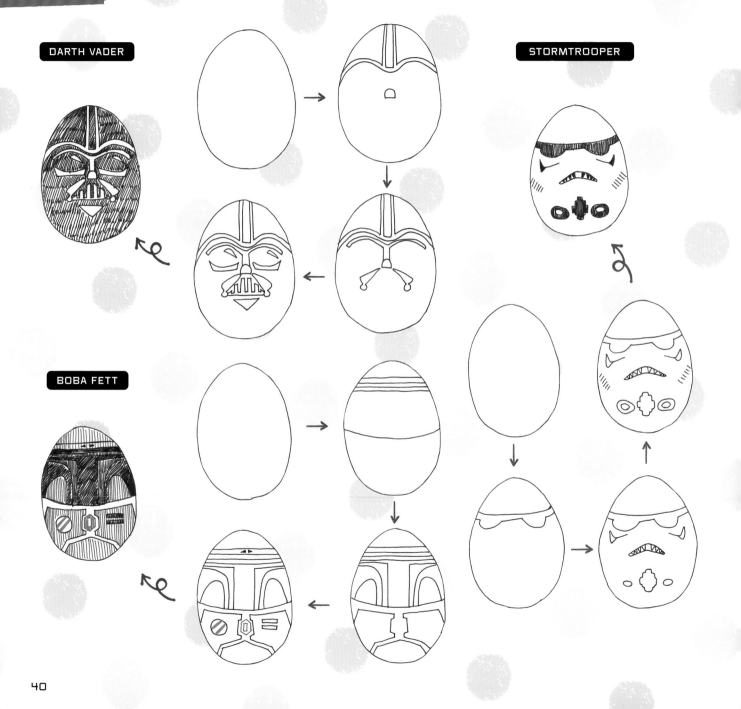

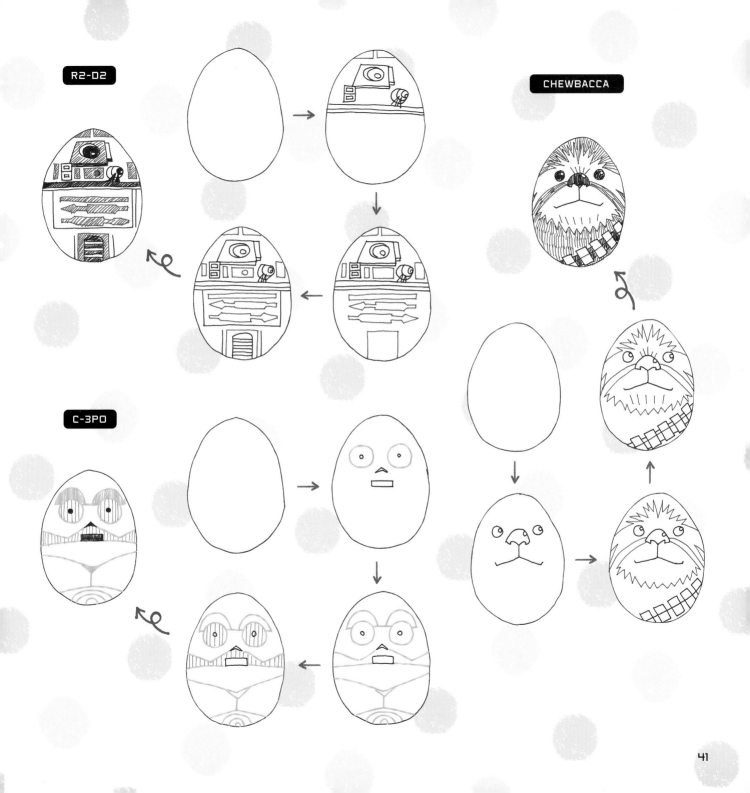

R2-D2

CHEWBACCA

C-3PO

Draw Halloween illustrations using black and orange colors.

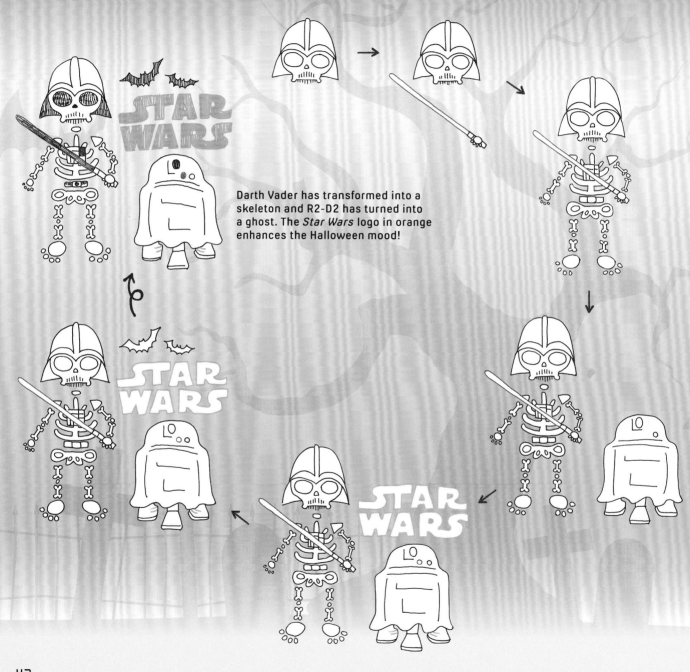

Darth Vader has transformed into a skeleton and R2-D2 has turned into a ghost. The *Star Wars* logo in orange enhances the Halloween mood!

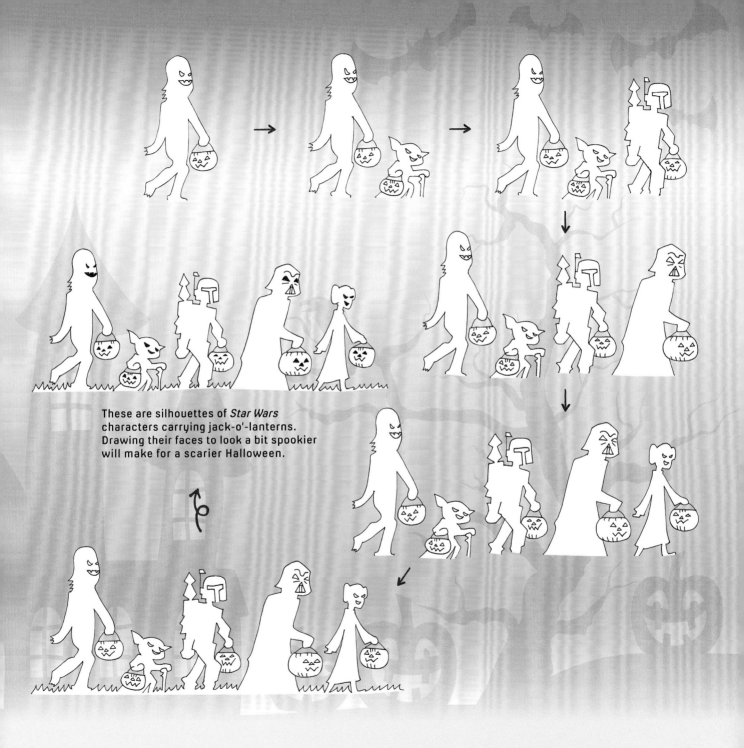

These are silhouettes of *Star Wars* characters carrying jack-o'-lanterns. Drawing their faces to look a bit spookier will make for a scarier Halloween.

Draw illustrations for winter by combining snow with Christmas motifs.

R2-D2 is wearing a red scarf.

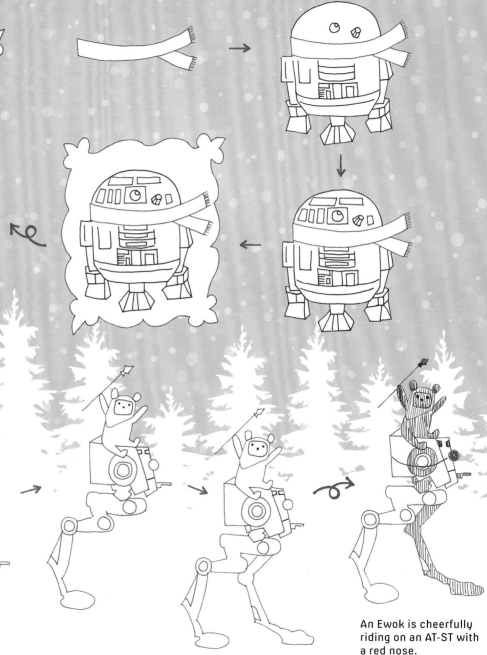

An Ewok is cheerfully riding on an AT-ST with a red nose.

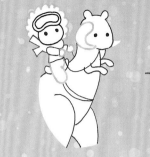

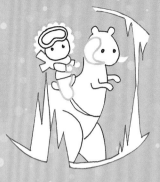

MERRY HOTHMAS

Draw an illustration that combines a tauntaun, Luke, a Christmas logo, and ice.

MERRY HOTHMAS

TRY THIS!

Arrange the above illustrations into a scene where they are running on the ice, away from danger.

45

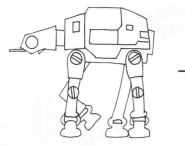

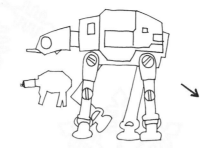

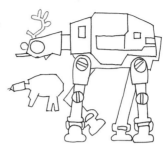

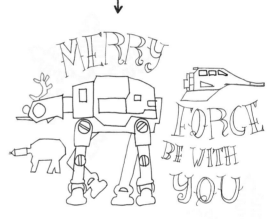

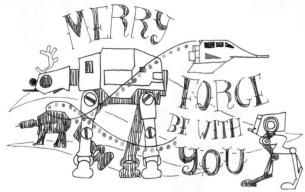

Decorate around an AT-AT dressed as a reindeer.

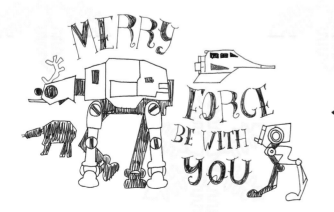

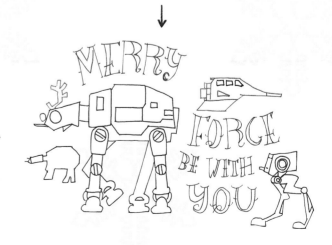

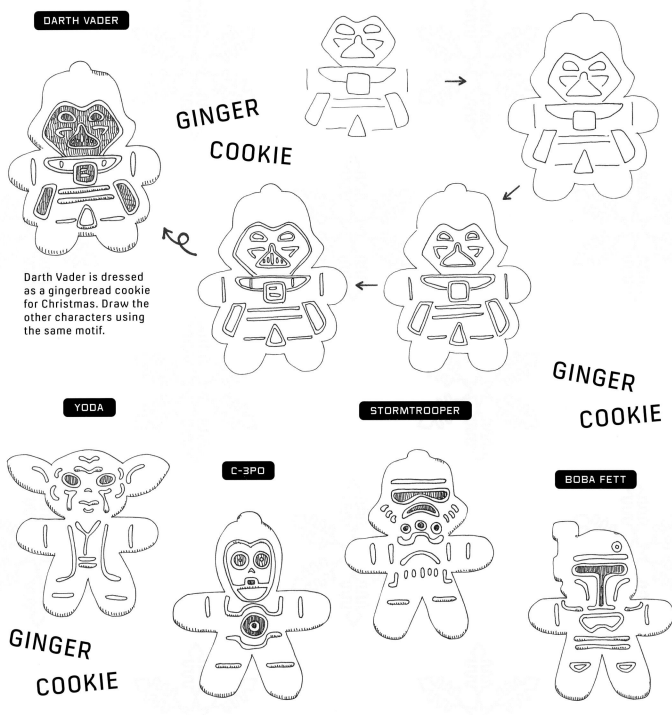

DARTH VADER

GINGER COOKIE

Darth Vader is dressed as a gingerbread cookie for Christmas. Draw the other characters using the same motif.

GINGER COOKIE

YODA

GINGER COOKIE

C-3PO

STORMTROOPER

BOBA FETT

47

SILHOUETTES

Draw silhouettes of each *Star Wars* character.

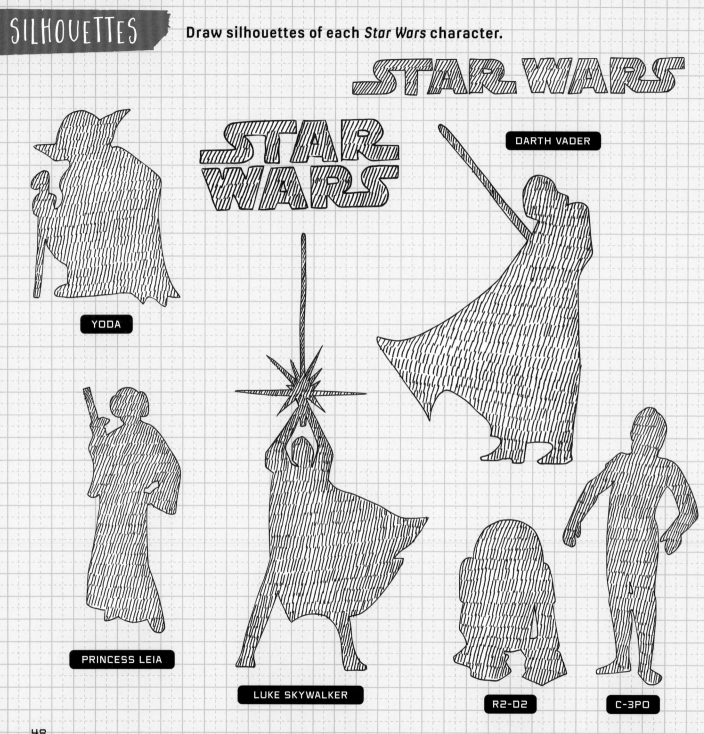

STAR WARS

STAR WARS

YODA

DARTH VADER

PRINCESS LEIA

LUKE SKYWALKER

R2-D2

C-3PO

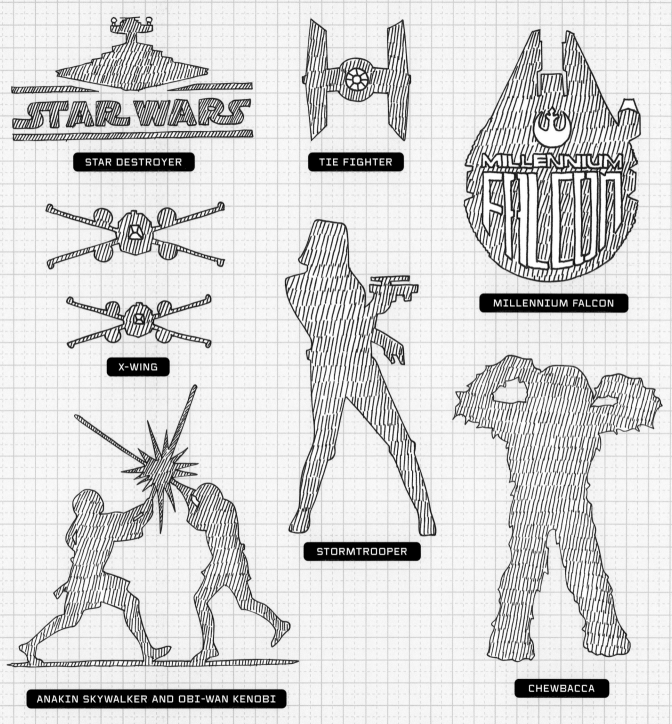

STAR DESTROYER

TIE FIGHTER

MILLENNIUM FALCON

X-WING

STORMTROOPER

ANAKIN SKYWALKER AND OBI-WAN KENOBI

CHEWBACCA

Draw cool emblems in the silhouette style.

DARTH VADER

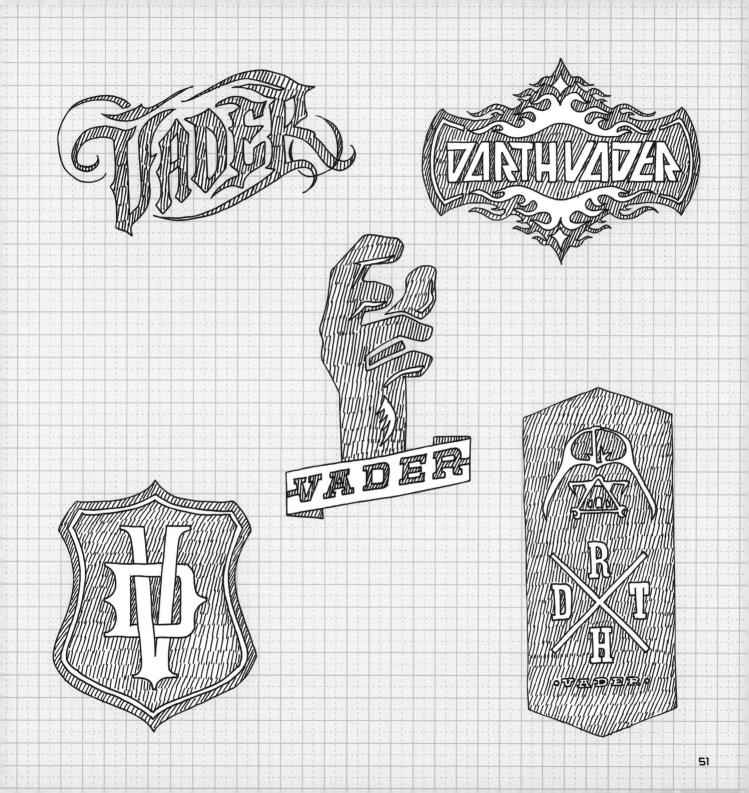

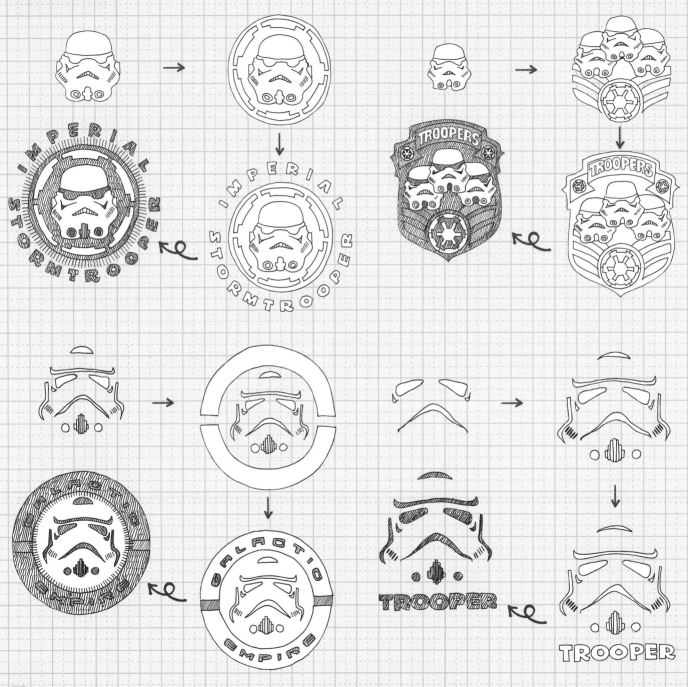

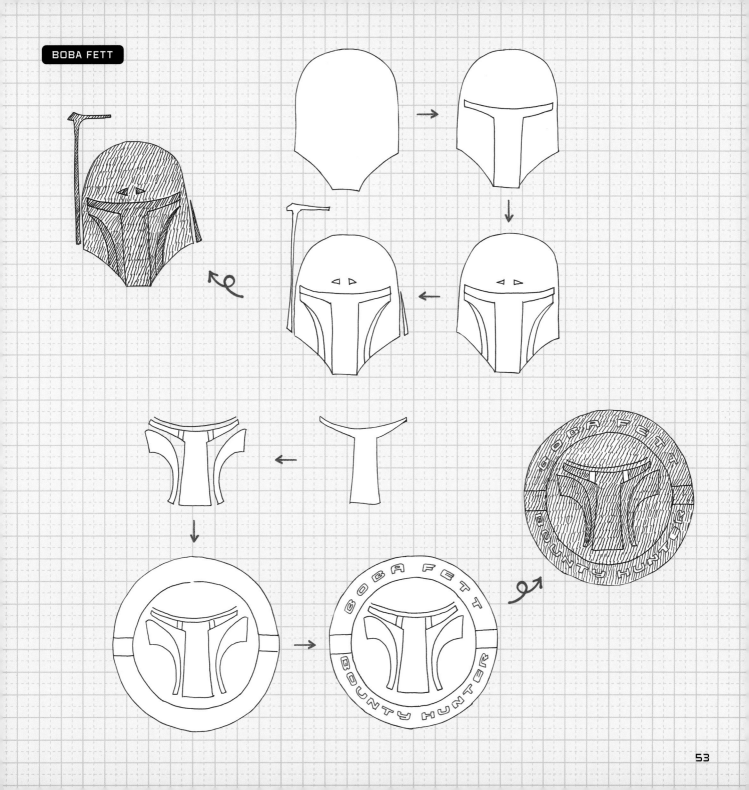

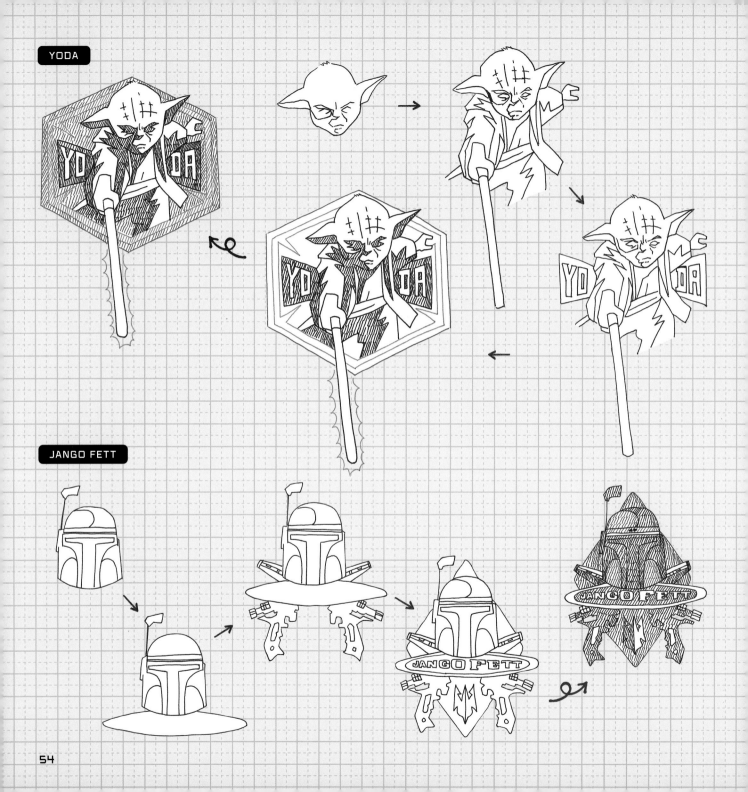

YODA

JANGO FETT

54

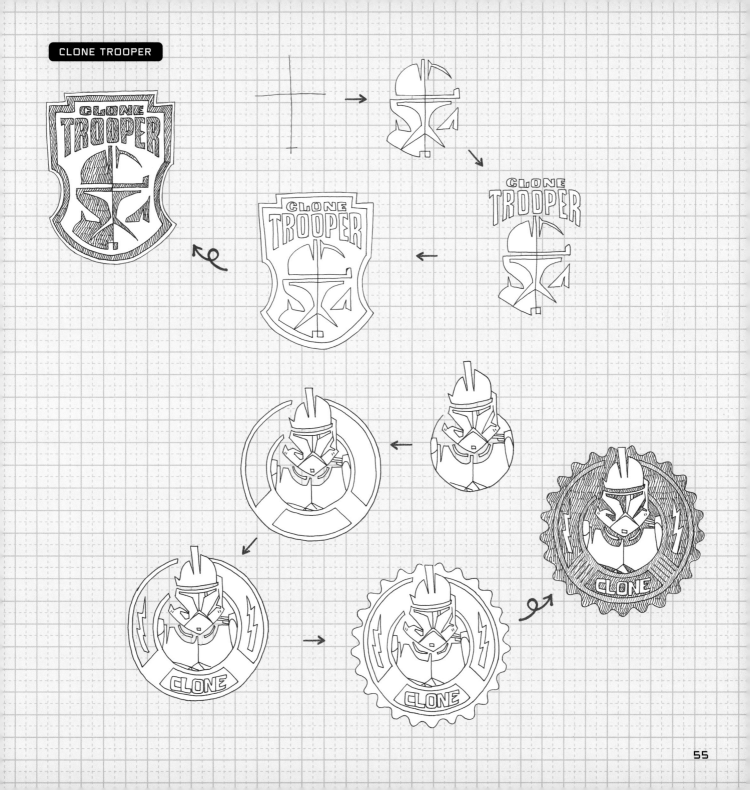

CHARACTER COLLECTIONS

Draw stylish character illustrations in both black and white and color.

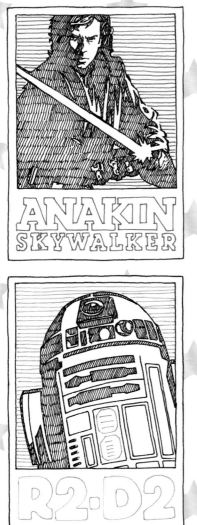

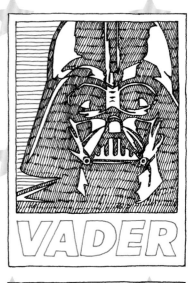

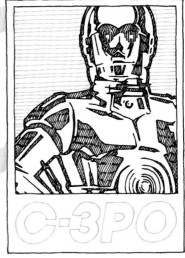

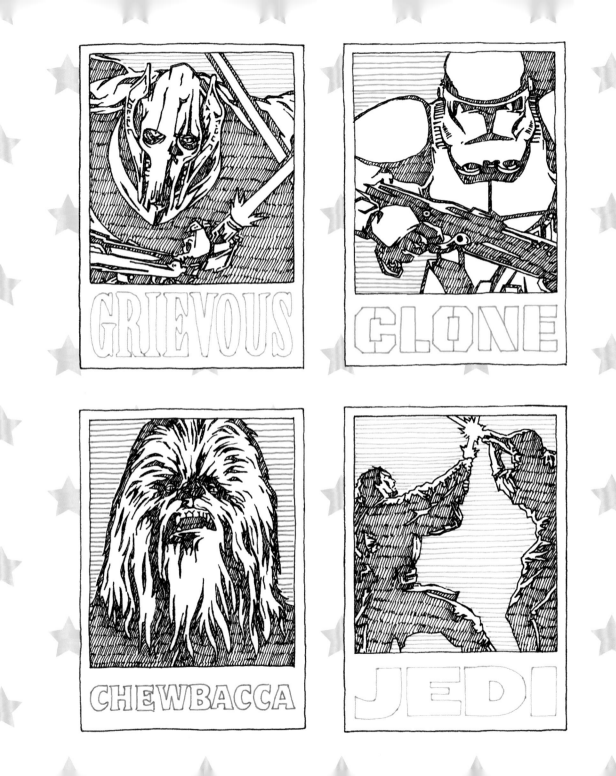

GRIEVOUS

CLONE

CHEWBACCA

JEDI

These designs are meant for stickers and badges, so we recommend using these to start.

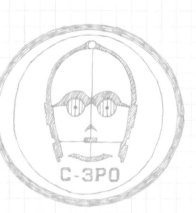

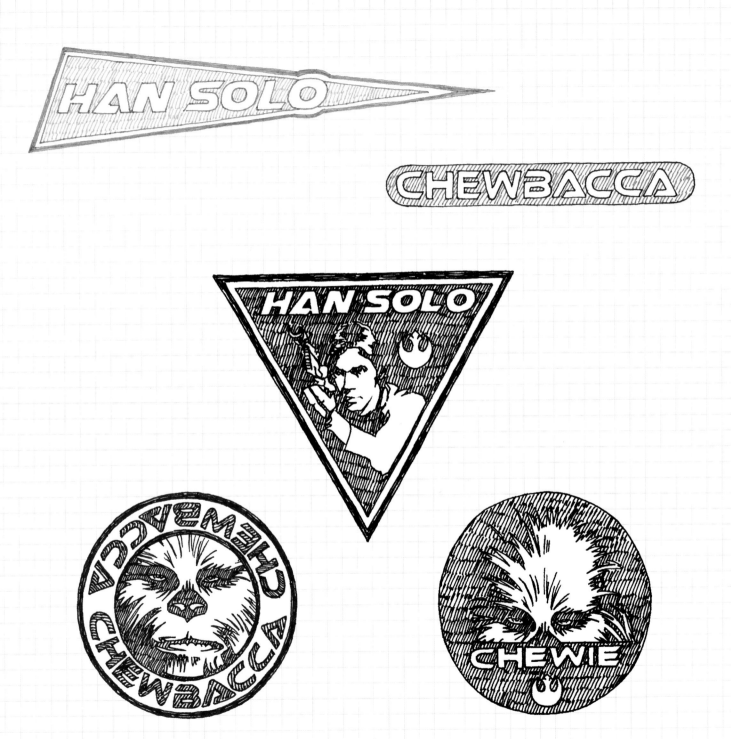

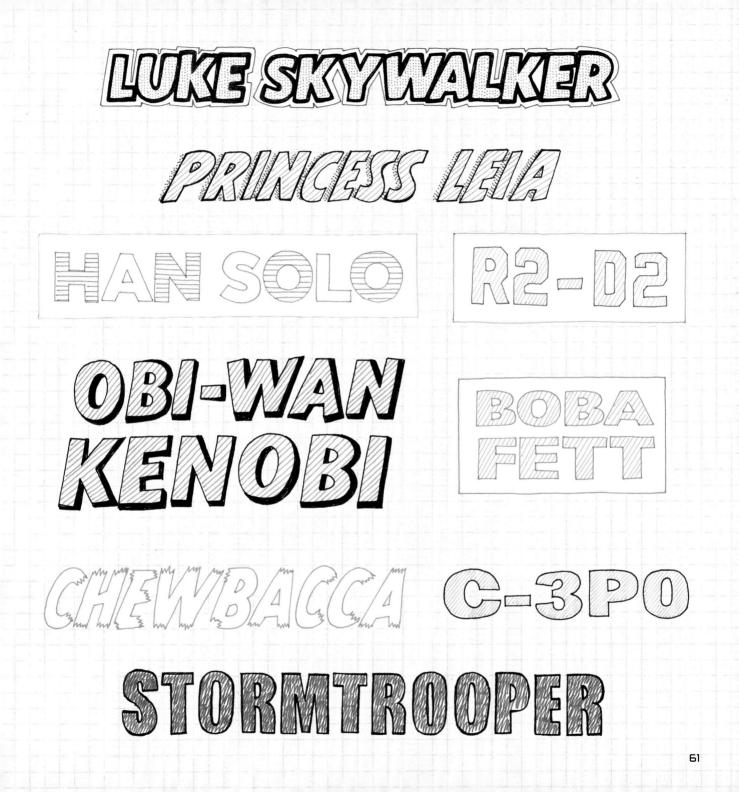

PHOTOGRAPHIC STYLE

Draw more realistic, three-dimensional illustrations.

DARTH VADER

PRO TIP
Draw light-sabers and the energy around them in different colors. Make them shine.

PRO TIP
Draw his cape using a curved line. The bigger the cape, the more presence it has.

PRO TIP
Draw a lot of lines to add shadows. It gives the illustration a three-dimensional effect.